YOU'RE STRONG, SMART AND

You Got This

Also by Kate Allan

You Can Do All Things: Drawings, Affirmations and Mindfulness to Help with Anxiety and Depression

It's Your Weirdness That Makes You Wonderful: A Self-Acceptance Prompt Journal

Thera-Pets: 64 Emotional Support Animal Cards

YOU'RE STRONG, SMART AND

You Got This

DRAWINGS, AFFIRMATIONS AND COMFORT TO HELP WITH ANXIETY AND DEPRESSION

BY KATE ALLAN, AUTHOR OF YOU CAN DO ALL THINGS

CORAL GABLES

Cover Design: Kate Allan
Cover Photo/illustration: Kate Allan
Layout & Design: Elina Diaz

For permission requests, please contact the publisher at:
Mango Publishing Group
2850 S Douglas Road, 2nd Floor
Coral Gables, FL 33134 USA
info@mango.bz

For special orders, quantity sales, course adoptions and corporate sales, please email the publisher at sales@mango.bz. For trade and wholesale sales, please contact Ingram Publisher Services at customer.service@ingramcontent.com or +1.800.509.4887.

You're Strong, Smart, and You Got This: Drawings, Affirmations, and Comfort to Help with Anxiety and Depression

Library of Congress Cataloging-in-Publication number: 2020933917
ISBN: (print) 978-1-64250-120-9, (ebook) 978-1-64250-121-6
BISAC category code: SEL004000—SELF-HELP / Affirmations

Printed in the United States of America

Table of Contents

Introduction 11

This Is for When You're Feeling Overwhelmed 14

This Is for When You Can't See What's Ahead 46

Whoever You Are Today Is PLENTY "Good Enough" 72

Self-Shame Doesn't Help 93

"Love" Is An ACTION 117

You Belong Here, I Promise 134

Conclusion 161

About the Author 162

Introduction

When I was twenty-five years old, a depressive episode stopped me in my tracks. I struggled to find purpose or meaning in anything—my brain seemingly refused to produce the positive feelings of connection, creation, or victory. And even worse, my never-ending internal monologue continually repeated how much of a disappointment and a failure I was.

What changed? While browsing a blog, I came across the art of rubyetc. She had an amazing way of illustrating depression struggles with humor and honesty. And I realized I wasn't alone.

With encouragement from a kind and helpful therapist, I began writing my own affirmations and doodling cute little animals in the hopes of trying to find compassion for myself. Though I didn't feel I *deserved* goodness, I was determined that for every shame, disappointment, and negative judgement I thought and felt, I could find a kind counter thought. I theorized that kindness and colorful animals could help me heal. And you know what? They did actually help. My depression has never

lifted entirely, but I have learned the battle is only half as painful when I've stopped shaming myself for it.

So, after several years of writing and drawing affirming animals to help me get through, I created this book. *You're Strong, Smart, and You Got This* is my attempt to accumulate all the lessons I've learned and philosophies I've adopted in order to live a fulfilling and productive life, despite depression and anxiety. I wrote each chapter to my younger self, with confidence that if I could invent a time machine and present this to a younger Kate, she would not have felt so alien and hopeless.

I obviously do not have all the answers, but I have come a long way. And my philosophy is, if I find something that helps, I want to share it. We all have our messes to navigate our own way though, right? I hope that in sharing mine, you, too, will feel less alone.

Dear Past Kate,

I made this book for you. Since I didn't get a chance to read anything like it when I was your age, I wrote it instead. Within, you'll find several short letters that I know will help you with a lot of your specific struggles. Oh, and drawings, too. Please: Never. Stop. Drawing.

When you're feeling overwhelmed, when you're afraid of not knowing what's ahead, when you feel like you're just not good enough, when you hate yourself, when your relationships don't quite feel right, and you feel like you don't belong anywhere—please READ THIS. No matter what problem feels insurmountable right now, just remember: You're Strong, Smart, and YOU GOT THIS.

Love,
Future Kate

This Is for When You're Feeling Overwhelmed

I'm sorry, I'm not purposefully avoiding you...

I'm just overwhelmed and recharging.

Hello Younger Me,

You are trying your hardest, but it never feels like it's quite enough, does it? There's always some sort of disaster looming ahead, right? Well, as an older, more experienced version of you, I can tell you—this feeling never really goes away. I'm sorry, I know that's bad news.

But, you know what? You *will* get better at dealing with it. You'll learn to view your days in segments of time—yes, you may have an upcoming test you could very well fail, BUT it's only an hour out of your entire day, and afterwards you can drink some tea, play a video game, and chat with a friend.

No matter how
AWFUL today is,

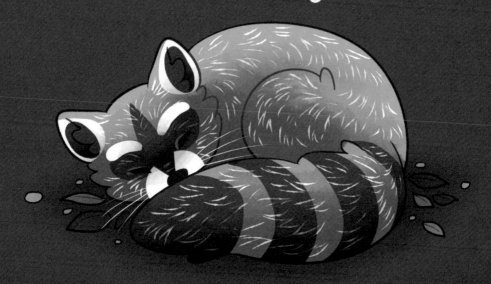

you get to curl into
bed at the end of it.

And that hitch in your chest that continually keeps you from properly breathing? You will come to learn that when you exhale fully, hold your breath for a second, and THEN inhale, you can calm that hitch quite effectively.

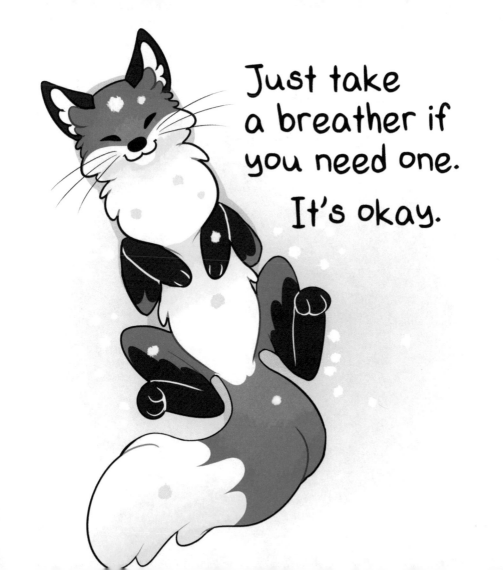

Just take
a breather if
you need one.

It's okay.

Also, when your mind is full of those loud, confusing, stabbing thoughts? You will learn that when you write out all the things that HAVE to get done in your day, you then can focus on the important things and effectively block out all the mental noise.

Reduce everything down to the most basic steps, and everything will work out fine.

And the most important thing you're going to learn, little nerd? You are going to mess up, a lot. And you'll learn that, over and over again, you will come out the other side completely intact. In fact, with every difficulty you face down, you will actually become stronger, more resilient, and even more capable than you were before.

It's going to be challenging, and I am sorry for how little you will feel prepared for any of it. But I know you will prove yourself, again and again. You got this, you'll see.

Love,
Thirty-Year-Old You

If You're Feeling Overwhelmed, These Kind Drawings Are for You

Crying doesn't mean you're weak or losing it; it's a sign that you're overwhelmed, which means you are trying. And that's really all that matters.

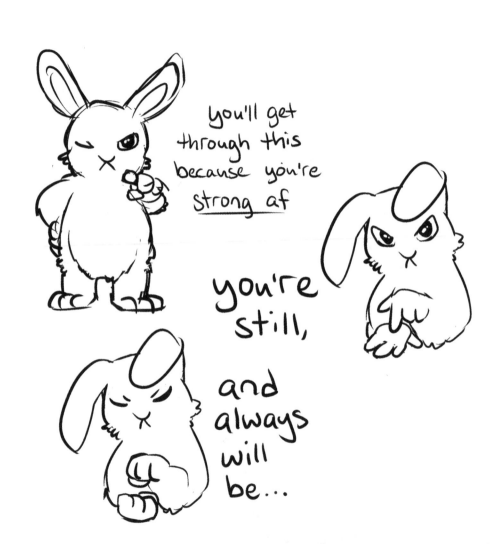

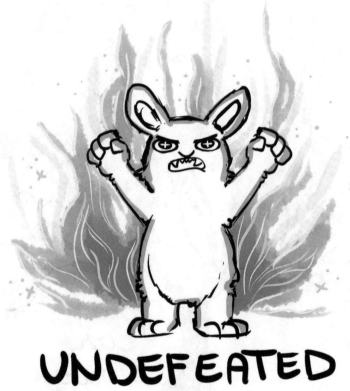

UNDEFEATED

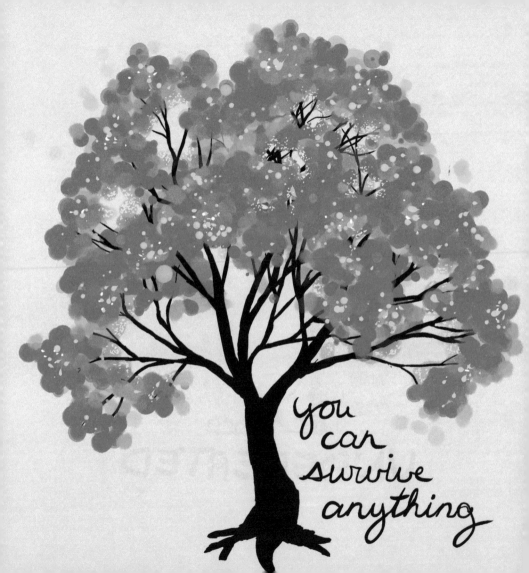

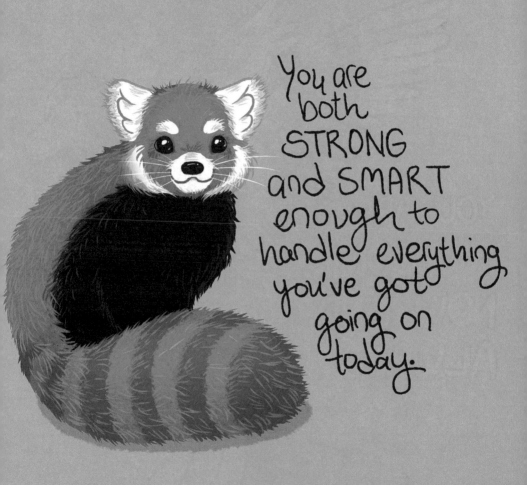

You are both STRONG and SMART enough to handle everything you've got going on today.

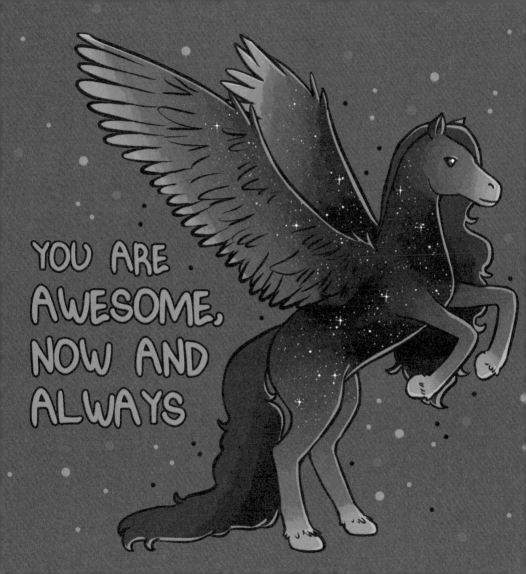

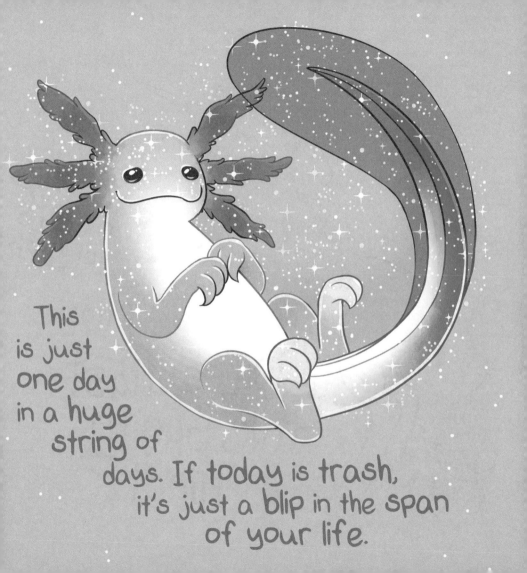

This is just one day in a huge string of days. If today is trash, it's just a blip in the span of your life.

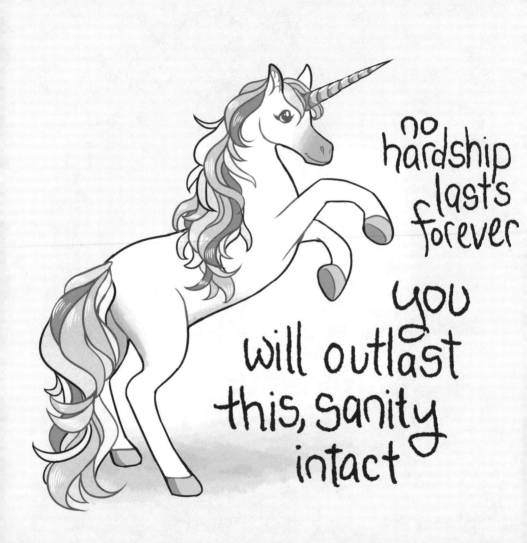

no hardship lasts forever

you will outlast this, sanity intact

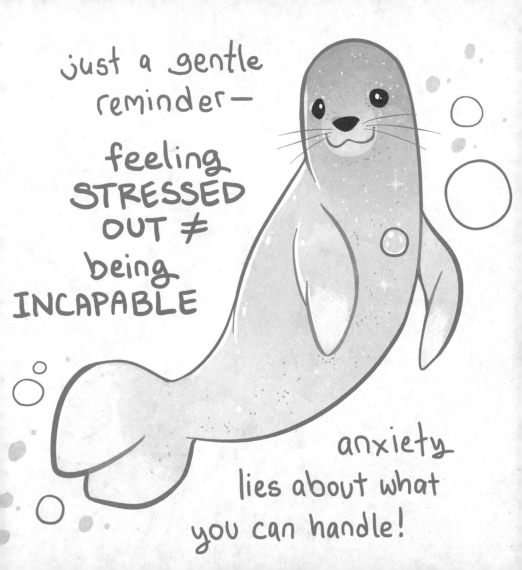

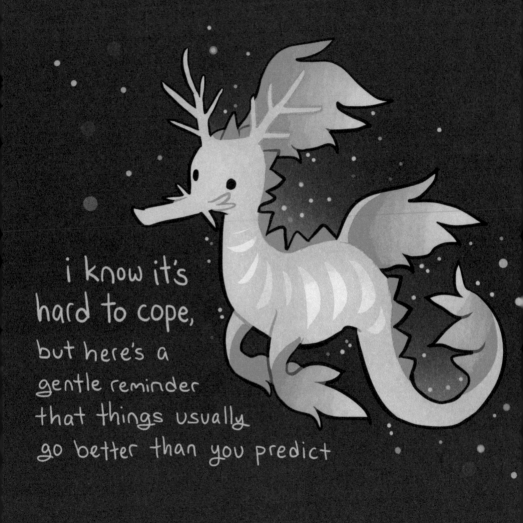

i know it's hard to cope, but here's a gentle reminder that things usually go better than you predict

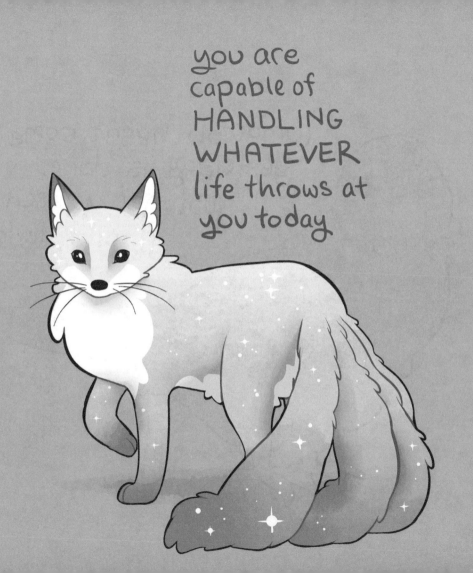

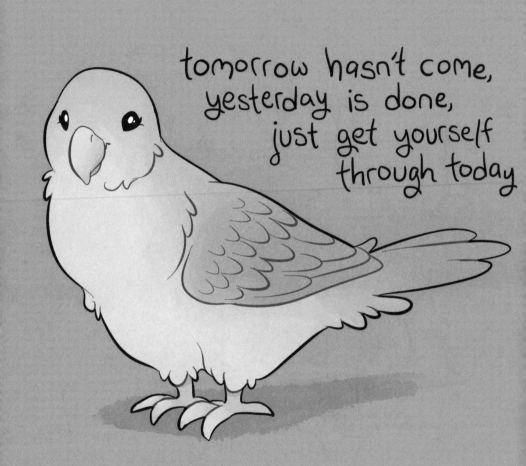

I rarely feel safe,
and I rarely feel capable,
but I can
still do hard
things.

I know you'll make it through this.

You have YOU.

Hey, you don't need to face tomorrow, or next week, or next year right now.

Just get yourself what you need today.

Being overwhelmed doesn't
mean you're weak or incapable.

We just need
a long while to recharge,
sometimes.

IT'S EVIDENT YOU'VE FOUGHT WELL

HERE'S A GENTLE REMINDER THAT YOU WILL NEED TO REST WELL, TOO

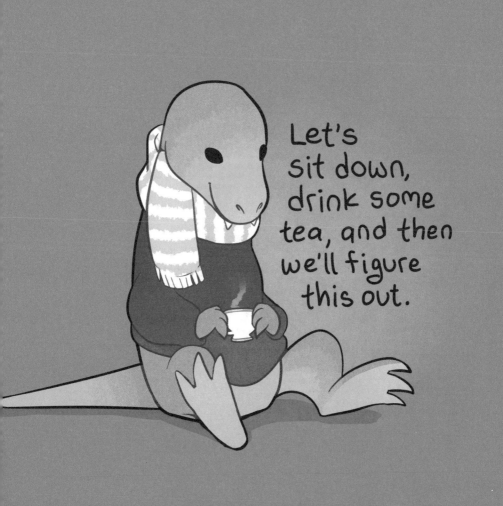

This Is for When You Can't See What's Ahead

I'm good with problems
I can face head-on,

But if I don't know what
I'm facing, I fall apart.

Hello Younger Me,

So, THE UNKNOWN. There is NOTHING your mind freaks out about more than facing an uncertain future, am I right?

There's a lie that anxiety tells you: if you make ANY mistakes, ANY AT ALL, you will royally mess up your future. Everything feels high stakes, basically all the time. Yikes.

Well, one thing you need to acknowledge is, although your mind is sabotaging you and keeping you from being able to focus or act with confidence, it is actually trying to protect you. Bizarre, right?

Your lizard brain thinks it's helping you survive when you feel your breath catch from a text message popping up on your phone. And honestly, I think there's some strange comfort to be found in that; as if your anxious mind were a big goofy dog who is doing his best but is actually just making a mess. Intentions matter, you know?

Something else you will find helpful is to follow your negative predictions with, "But I can take it," or, "I can handle it." For example:

"I'm probably going to fail this driving test, but I can handle that."

"I messed up and my boss might yell at me again, but I can take it."

"I think my boyfriend is going to break up with me.. But whatever, I'll deal with it."

Leaning in to the pain and fear can loosen anxiety's hijacking of your mind. You may have no idea what's headed your way, but if you keep telling yourself that you're capable of handling whatever happens, your mind will panic less and less often.

Good luck!

Love,
Thirty-Year-Old You

If You're Struggling with Anxiety Over Not Being Able to See Ahead, These Kind Drawings Are for You

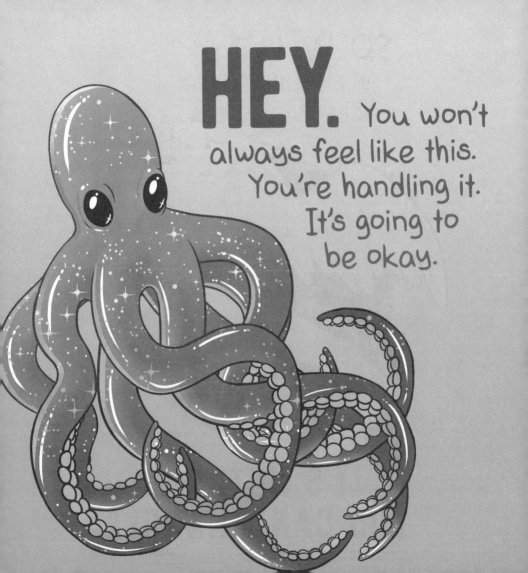

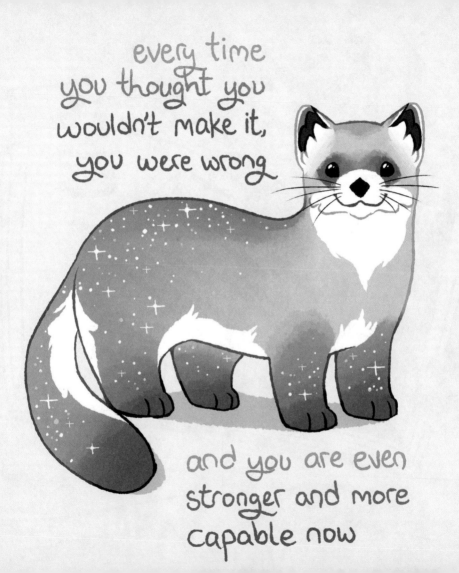

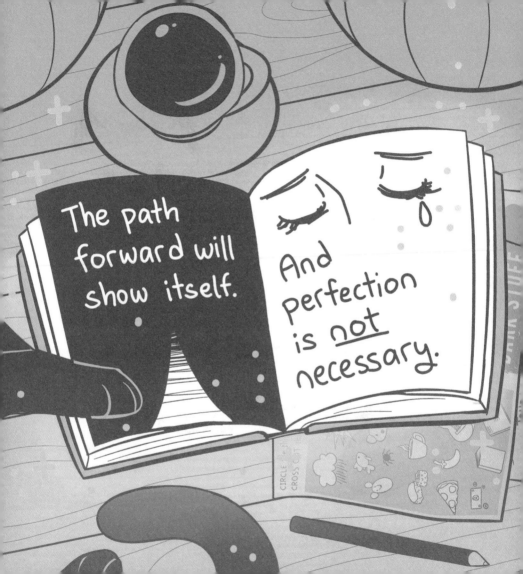

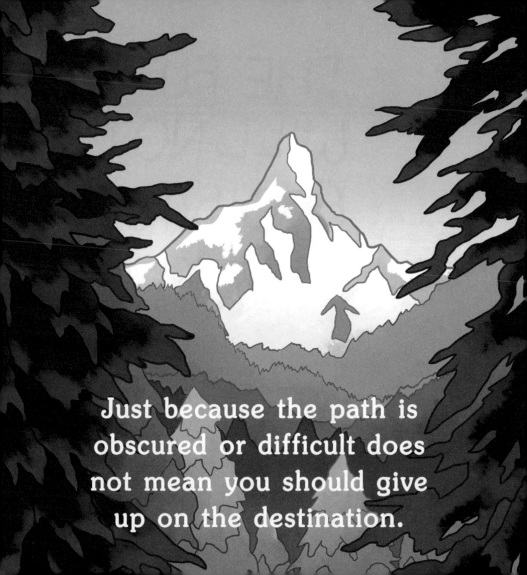

Just because the path is obscured or difficult does not mean you should give up on the destination.

THE FUTURE WILL NOT BE A DISASTER.

You just have anxiety, sorry.

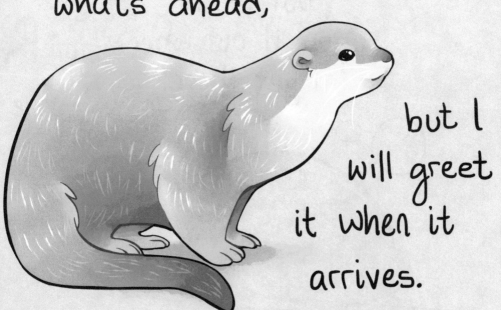

I don't know
where I'm headed,

but I can
figure it out when
I get there.

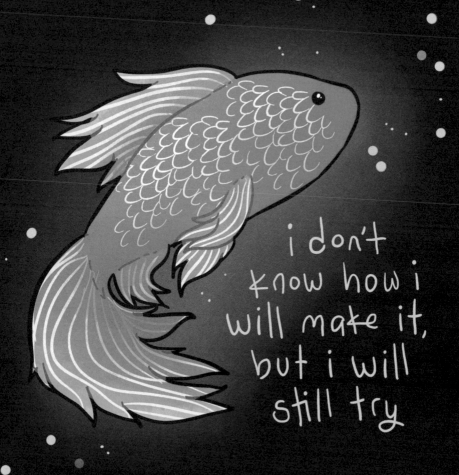

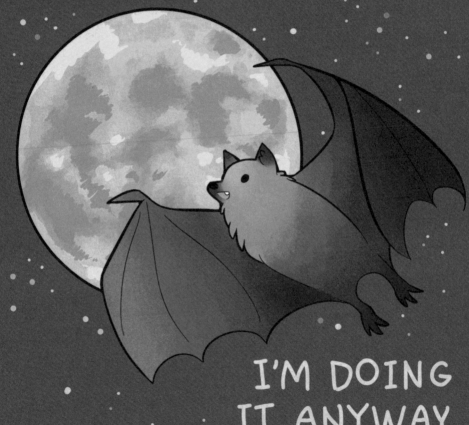

Here Are Some More Gentle
Reminders for You

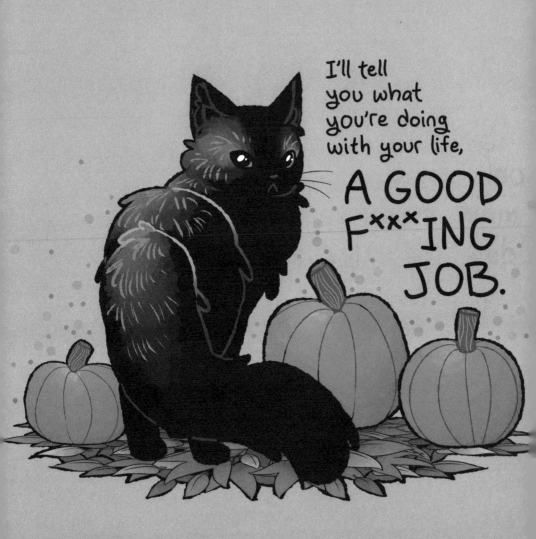

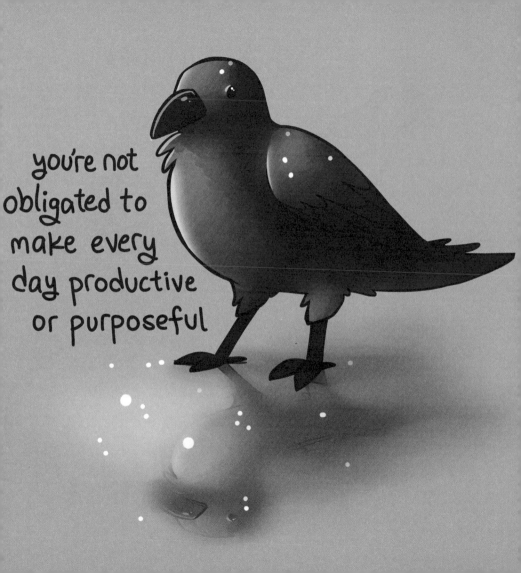

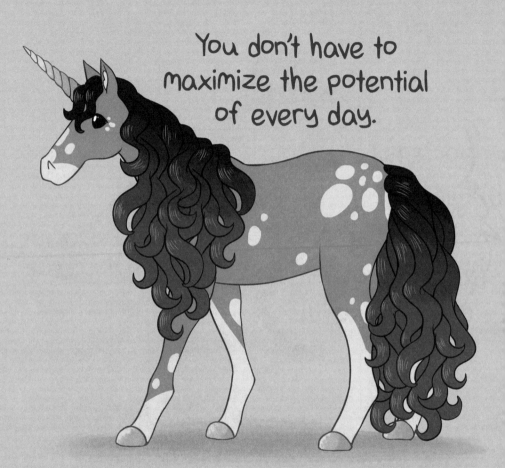

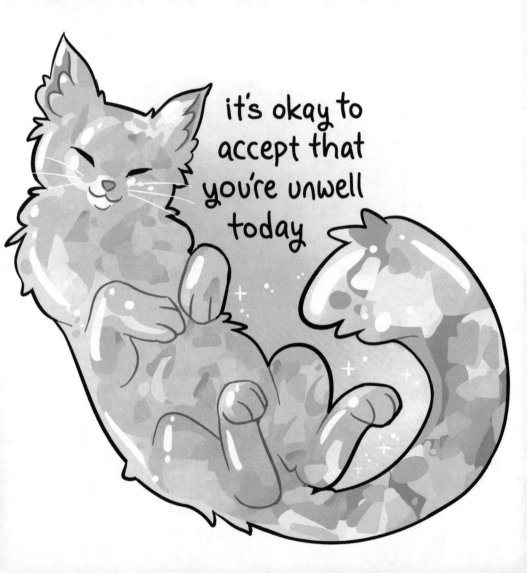

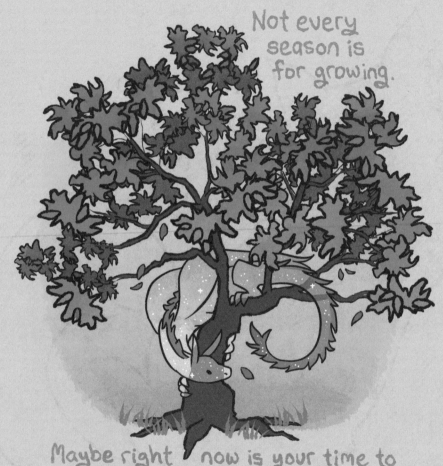

Not every season is for growing.

Maybe right now is your time to be dormant. Step back and rest for a while.

EVERYONE GROWS AT THEIR OWN RATE

TRY TO HAVE PATIENCE WITH
YOUR PROGRESS

Whoever You Are Today Is
PLENTY "Good Enough"

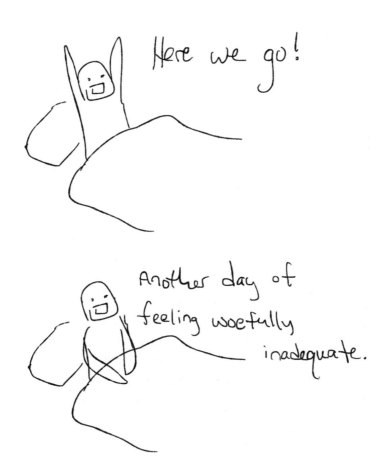

Hello Younger Me,

Okay, so I have something to admit; I didn't really turn out the way you wanted. You hope to grow up popular, fit, and pretty, and have all your ducks in a row. I know that you want your future to be free of many of your current struggles, i.e. loneliness, confusion, and the overall feeling of just being "not right." Well, instead, you will come to be a bit of an anxious mess, essentially the adult version of who you are now. Whoops.

I mean, honestly, you will have to experience a grieving process over the "you" you hope to become. You may find comfort in the dream that you'll be able to assuage your anxieties by becoming some sort of superwoman; a person who knows how everything works, is full of strength and tenacity, and is beloved by all. But truthfully, you will come to find that no matter how hard you try, you will still disappoint people. You will fail to live up to expectations. And it doesn't matter how funny and kind you are, there will be people who will not find you appealing.

But, I think you will find that, though it's very painful to be rejected by others, you will also discover that it is WONDERFUL

to be your own unique flavor. There's something awesome about owning your "niche." There is no better feeling than being seen for who you are and being celebrated for it by people who really "get you."

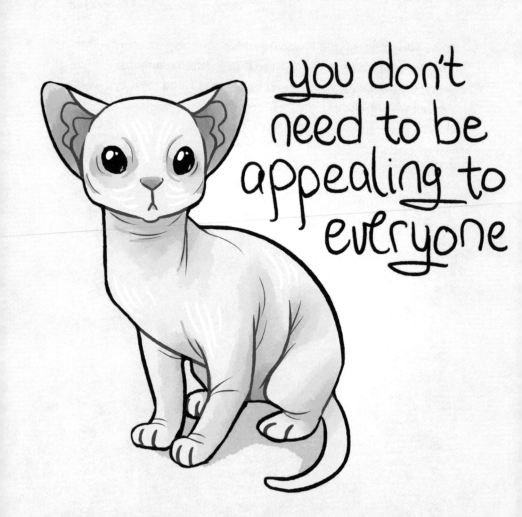

you don't need to be appealing to everyone

It's not easy, but trying to view yourself from the perspective of a friend is so much healthier than changing yourself in the hopes of winning over someone who dislikes you. A friend will not be bothered by your contradictions—if anything, they'll appreciate the surprises. I promise, your flaws are not as evident as you think. And when your flaws do show themselves, they are not as big of a deal as you think they are.

People don't look at you and see mistakes. And if they do... they're kind of jerks.

Love,
Thirty-Year-Old You

If You Struggle with
Accepting Yourself,
These Kind Drawings Are for You

I'm not
who I
want
to be,
but
I'm not
so bad,
either.

you can be a
mess today.

it's okay.

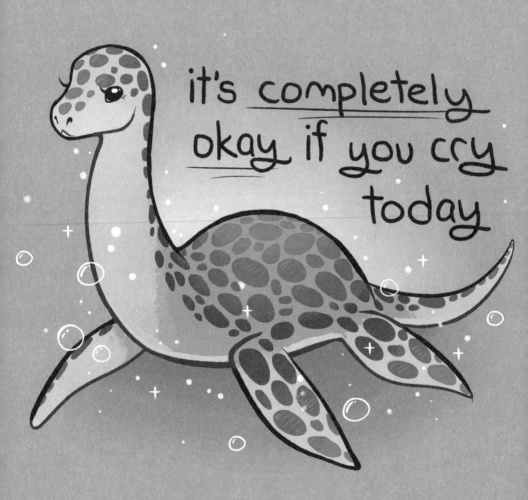

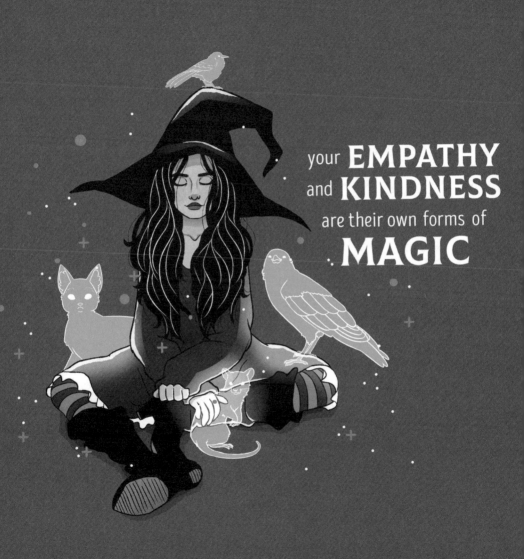

your **EMPATHY** and **KINDNESS** are their own forms of **MAGIC**

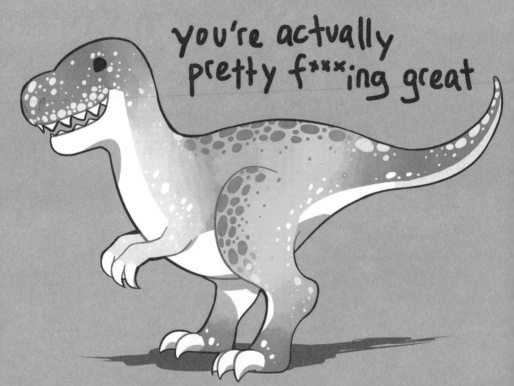

Here Are Some More Gentle
Reminders for You

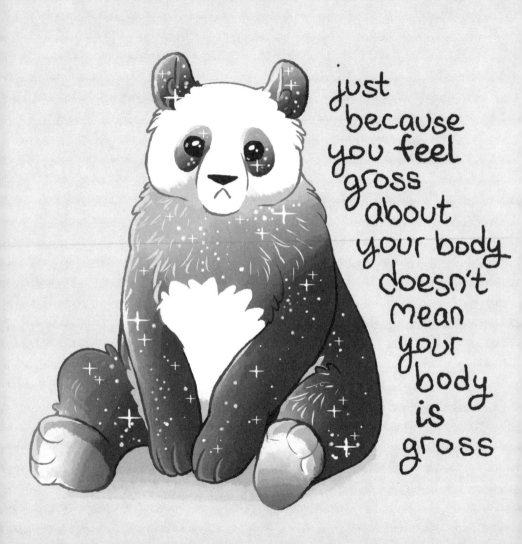

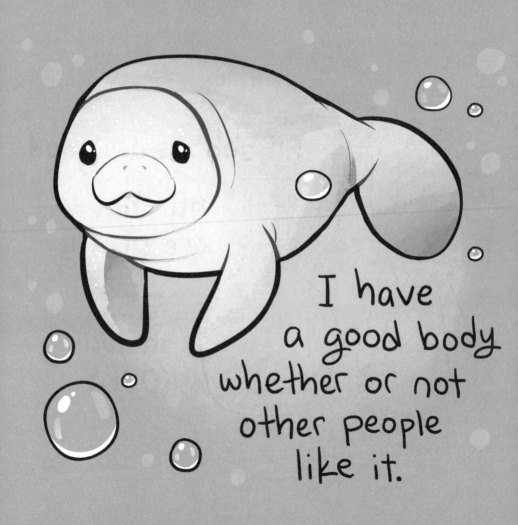

I have
a good body
whether or not
other people
like it.

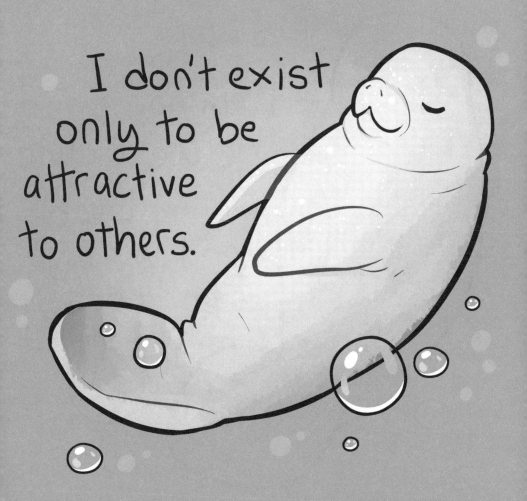

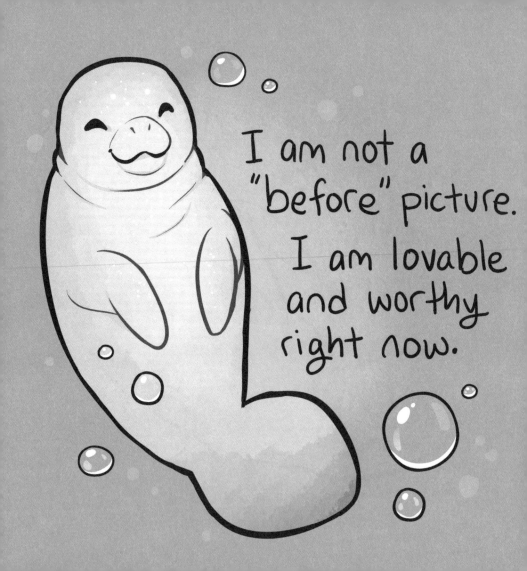

Self-Shame Doesn't Help

Today, I want to shave my head,

Erase every drawing,

Drive until I have no idea where I am.

Hello Younger Me,

That self-hatred is potent, isn't it? When you feel lost, you tend to quit jobs or drop out of school programs. And then you turn to coping mechanisms that don't move you forward, which you use as justification to mentally abuse yourself more. I see it. I know that while your friends are traveling, getting degrees, starting careers, and having babies, you are playing video games alone and loathing yourself.

Unfortunately, self-shame does little to move anyone towards health or happiness. It is imperative that you learn that you are actively sabotaging your life by repeatedly putting yourself down. Shame and self-abuse only ever result in isolation and disconnect rather than what you actually want from life: productivity, joy, and feeling understood/seen.

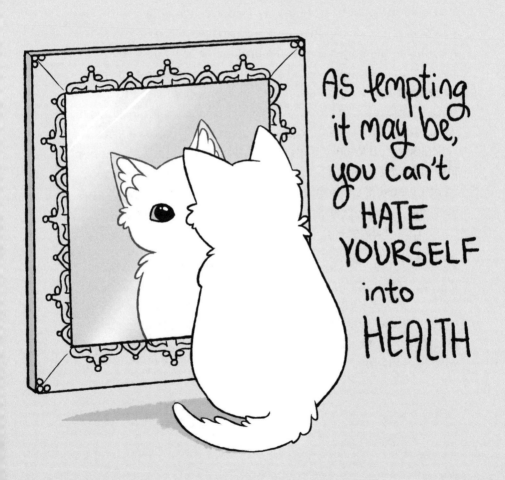

As tempting it may be, you can't HATE YOURSELF into HEALTH

It's also important to start setting kinder expectations for yourself, ESPECIALLY when you are living with illness. You wouldn't expect a person with a broken leg to be able to complete a marathon, right? Yet, while you're depressed and suffering from daily panic attacks, you expect yourself to have a robust social life, know exactly what to major in, know what job to aim for, and to always be enjoying yourself. It's ridiculous. You know what's more realistic and leads to a better life? Showing yourself some compassion. Leave yourself room to be confused, uncertain, and sad. You have a tendency to set your bar so high, that even without any mental illness at all, you have no chance of vaulting it.

The other major problem in being down on yourself is how much you're ignoring whole sides of YOU. You have your own preferences, experiences, insight, and ways of showing love to others. There is nobody else like you, as cliché as that sounds, and it's a beautiful thing. You are irreplaceable to the people who care for you.

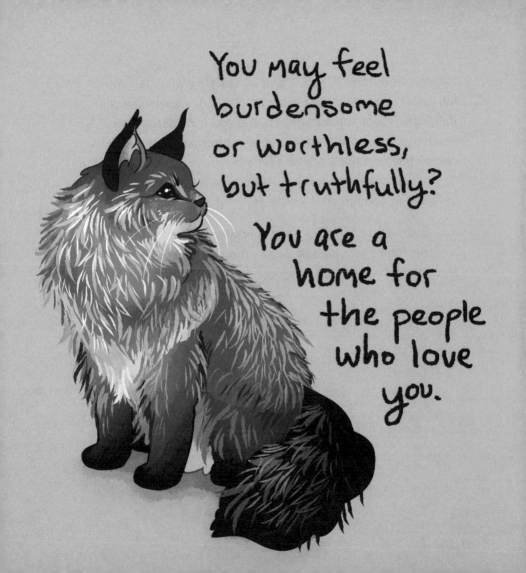

I understand how difficult it is to accept yourself when you fail to live up to your own expectations. I'm not saying it will feel "right" to let some things go. But you truly deserve to make room for compassion and understanding. There are completely legitimate reasons for why you're struggling. Please do not sabotage your future just because your present is not as lovely as you hoped it would be.

You deserve to have all of your energy and effort go toward a better future for yourself, rather than holding yourself back through self-abuse. You deserve a better life. You truly do.

Love,
Thirty-Year-Old You

If You're Struggling with Self-Abuse, These Kind Drawings Are for You

There's no need to be hard on yourself.

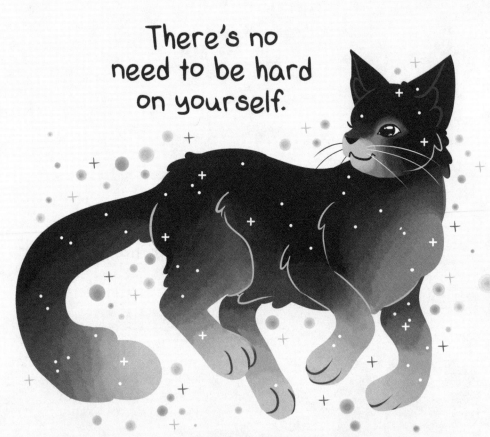

You're taking care of yourself, and you're doing fine.

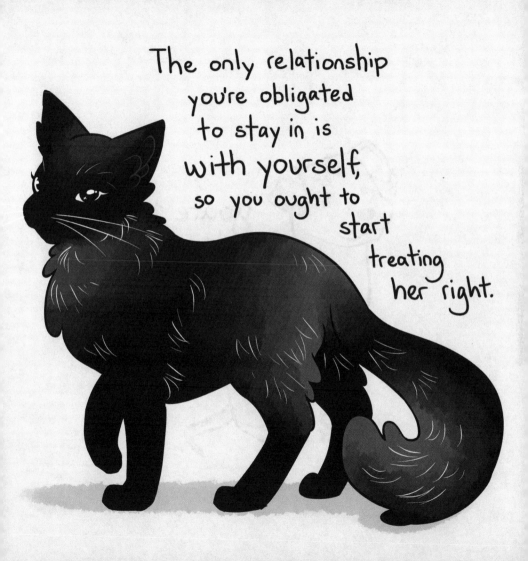

you're too
hard on
yourself

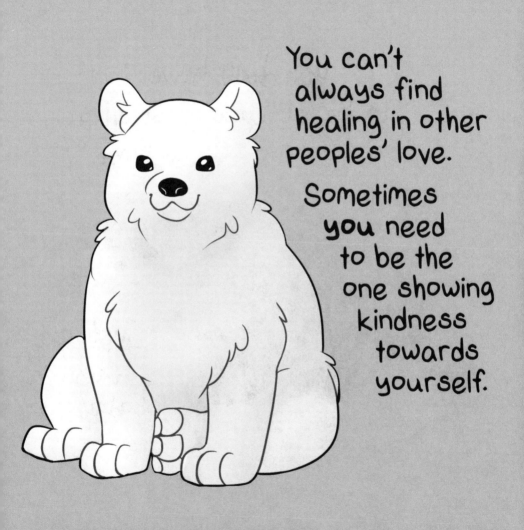

You can't always find healing in other peoples' love.

Sometimes **you** need to be the one showing kindness towards yourself.

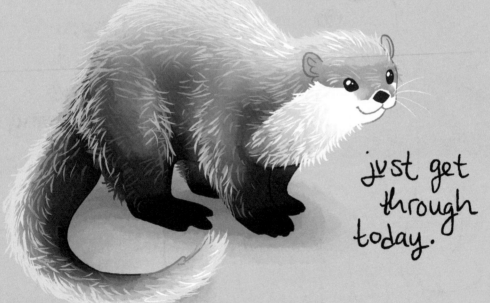

you don't have
to be at your best all of
the time.

just get
through
today.

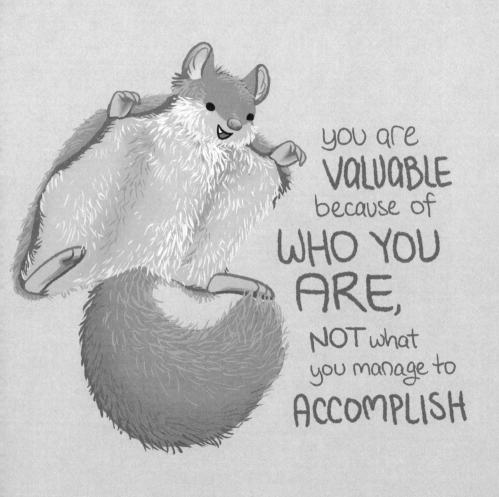

you are
VALUABLE
because of
WHO YOU
ARE,
NOT what
you manage to
ACCOMPLISH

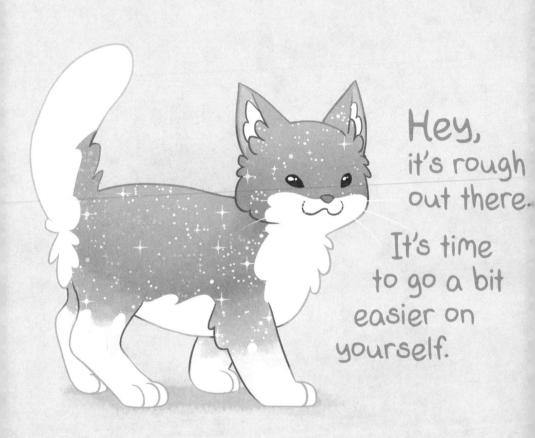

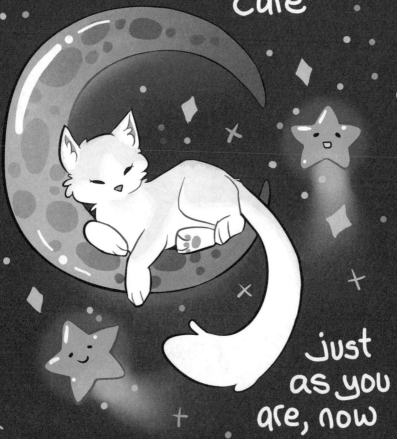

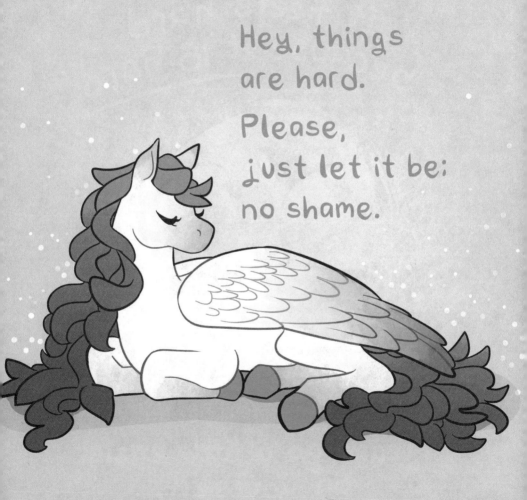

It feels hard because it IS hard.

Please go a little easier on yourself.

You can
only move
forward in
the ways
that make
sense to
you—

please do
not shame
yourself for
what you
didn't know.

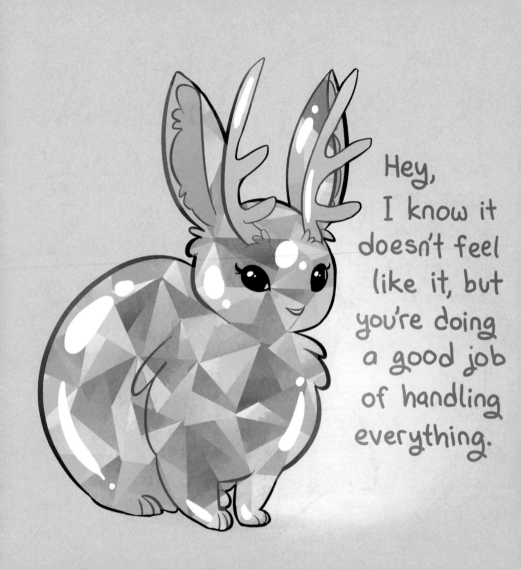

That voice
inside that says
you're too vulnerable
and weak must not
really know YOU at all.

**All I can see
is resilience
and tenacity.**

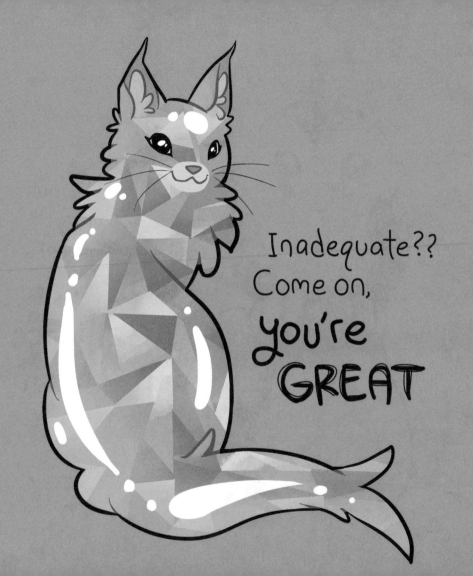

"Love" Is An ACTION

What Even Is Love, Anyway

someday you won't affect me anymore

Hello Younger Me,

When I look back on my life, I notice that I jumped from toxic relationship to toxic relationship, whether it was with family, friends, or romantic partners. Why did I stay in these relationships for as long as I did? Why would I continue a relationship where I often felt afraid, unwanted, inadequate, or "too much"?

One piece of the puzzle, I believe, is a hard lesson I learned somewhat late in my human experience: "love" is both an ACT (or set of actions) and a FEELING. A person can *feel* love towards you but not *act* with love towards you. They, in fact, can tell you, "I love/need/appreciate you" and not actually act that way at all.

For example, I remember a distinct moment in a previous relationship, where I told a person I cared for, "I don't think... you love me?" And though I admit I wasn't the most articulate, I was trying to express that this person often acted annoyed by my presence, burdened by my needs, and was known to roll their eyes at my jokes and observations. They, however, interpreted my meaning differently; "Of course I love you. Don't tell me how I feel." And honestly, this disconnect, to me, illustrates pretty well my lifelong confusion about love—how do people who love you treat you disrespectfully? What is it to be in a relationship with someone who *feels* love toward you but doesn't *act* like they love you consistently?

I feel like a common response to this question is the presentation of two lists: one, a list of what healthy relationships look like, and the other a list of abusive behaviors. And though that information is obviously valid,

I am not sure these lists would have helped me rise above the situations I found myself in. Why? Because I had an unfortunate belief that it was my responsibility to show these individuals how to love. I thought in order to be a good, loving, kind person, it was my job to show people how to not hurt me. Yikes. "If I just communicated better, if I just explained better, if I just DEMONSTRATED MY LOVE BETTER, then they'd understand how to love!" Unfortunately, this doesn't work at all.

There is a second painful truth I must acknowledge as well: I stayed in toxic relationships because I felt I was unworthy of healthy, true connection and kindness. That's the tricky thing about toxic relationships—when someone you trust and care for believes you are "too much," you may believe EVERYONE feels that way towards you.

I now feel frustrated about how much time I wasted on people who didn't even like me. I also feel sad for the friendships I could have pursued with people I liked, but at the time I refrained, because I didn't want to "corrupt" them or bring them down. I believed the lies I was told that I was unlikeable and unwanted.

BUT, we live and we learn. And what have I learned?

- You are worthy of kindness, care, and DEMONSTRABLE LOVE (words of affirmation, acts of service, receiving gifts, quality time, and physical touch), just as you are, right now. You won't become worthy after you lose weight, make the grade, impress your parents, become brag-worthy, stop swearing, or make more money, no. You're worthy now.

- There ARE people out there in the world who will delight in YOU—your humor, your insight, and your worldview. You don't need to mold yourself to fit what others want you to be, I promise you. There are good people you can find who would properly value the true, raw YOU.

The third truth I must acknowledge is that I often stayed in toxic relationships because I was terrified at the thought of being alone. I felt dread at the thought of total disconnect and isolation. Especially given the fact that, when I was in unhealthy relationships, I often had cut myself off from other family and friends.

I discovered a surprising solution: taking myself on dates. Yes, really. Taking the time to show my brain and body, "You are significant. You are an individual who stands on your own.

Your interests and desires matter." So, being out and choosing, by myself, everything I would eat and do helped me:

1. Get to know myself—in a park, what do I find most interesting to look at? Where is the best seat in a movie theatre? What style of dress do I feel cutest in? What kind of pizza is the most uniquely tasty? (By the way, the answer is pineapple, onion, jalapeno!)

2. Show myself how to value ME. I could demonstrate how I would like to be treated by others.

3. Get used to the feeling of being alone. This aspect was honestly the most difficult for me because I don't particularly *like* being alone (and somehow I ended up a freelancer who sits alone in an office all day, whoops), but I did learn the valuable lesson that being alone and being isolated are two different things. It turns out that a friendly interaction at the coffee shop or a karate class can go a long way towards fighting that sense of disconnect.

In any case, it takes a lot of bravery to walk away from an unhealthy relationship; it certainly is no easy feat. But I will tell you, in my experience, shedding unkind and manipulative relationships is SO VERY WORTH IT, even though being alone is

hard, too. I've discovered that when I stop spending energy on and time on people who drain me, I can then shower kindness on lovely people and myself instead.

You truly are worthy of respect, kindness, and compassion from yourself and the people around you, RIGHT NOW, just as you are at this very moment. I promise.

Love,
Thirty-Year-Old You

If You Are Struggling with
Feelings of Worthiness,
These Kind Drawings Are for You

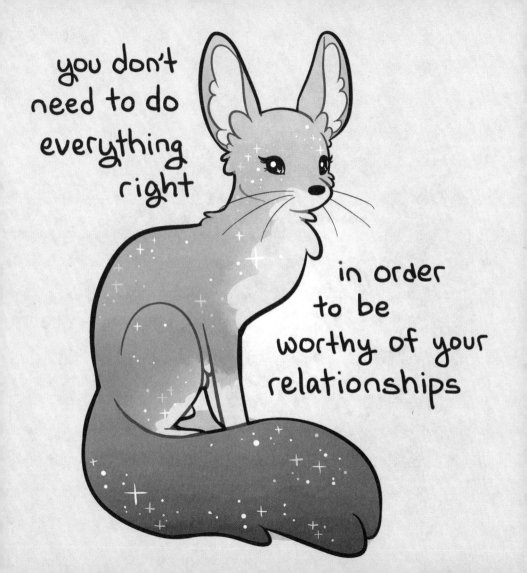

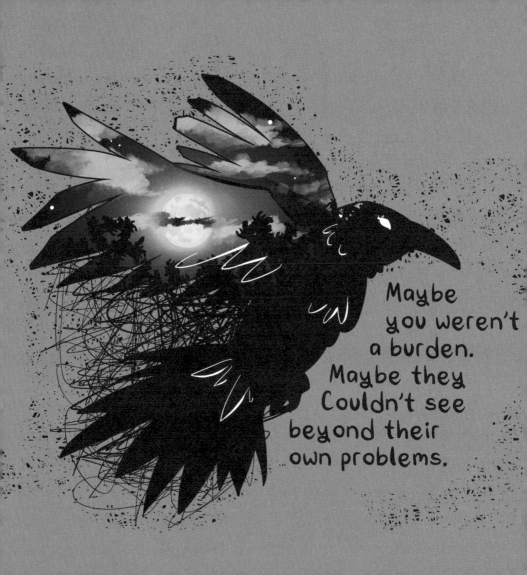

Maybe you weren't a burden. Maybe they couldn't see beyond their own problems.

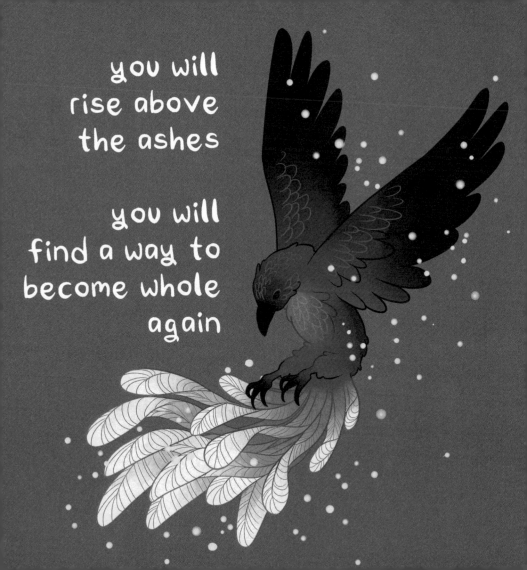

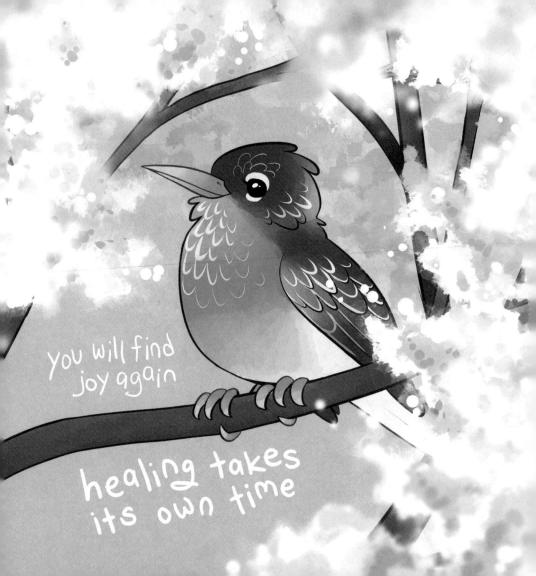

IT'S TRUE THAT THE SCARS
DON'T DISAPPEAR

BUT YOU DO OUTGROW THEM.

SURROUND YOURSELF WITH
WHAT'S GOOD IN LIFE, AND
YOU'LL MAKE IT THROUGH OKAY

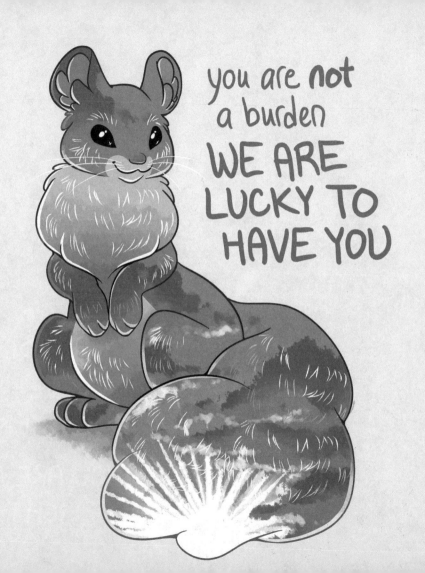

you are
CAPABLE,
you are
RESILIENT,
YOU ARE A
DELIGHT

you are not an endless
fountain of energy
and goodness

please, do
not sacrifice
your health or
wellbeing
for other
people

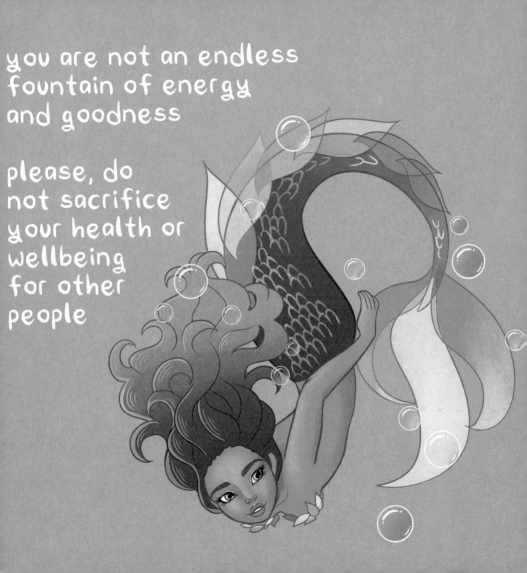

You Belong Here, I Promise

i always feel
like an outsider

Hello Younger Me,

We've been through many times of feeling like we didn't fit in
anywhere, haven't we? I can recall watching the other kids play
at recess in second grade, and not knowing how to join in the
fun. I remember being thirteen, sitting at the side of the pool
rather than jumping in, because it looked like everyone was

having a fine enough time without me. I remember, at fifteen, being the only girl who wasn't asked to dance. And even more recently, I blanked at the karate group's Christmas party, because I couldn't remember how to talk to people I wasn't yet comfortable with (yes, I'm sorry it still happens to you at thirty, but it's okay!)

And *oof*, writing out those moments does NOT FEEL GOOD, I tell you. There's an intense sense of *wrongness* and *shame* when I recall those times. I feel like I should hide them away, thinking, *If anyone ever reads this and finds out how much of a loser I am, they'll never want to talk to me again*. But the actual reality is, ABSOLUTELY EVERYONE HAS MOMENTS LIKE THIS. Very few people fit in everywhere they go, with absolutely everyone they meet.

When I look back on those times of disconnect and isolation, two things stand out:

1. Every time I have struggled to make a connection, *it was temporary*. I may not have had a friend in second grade, but the following school year I was friends with nearly my entire class.

2. The hardest times in my life were when I allowed the negative thoughts that accompany disconnect and isolation to hijack my view of myself; i.e. "I don't have any friends in this group" often leads to, "I can't make friends in this group because I don't belong here" which quickly descends to, "I am worthless, and I don't belong anywhere." These sorts of beliefs about myself result in depressive episodes which prevent me from feeling any connection and joy.

Ugh, thought spirals. I will tell you what, younger me—you will learn it's vitally important for your mental wellbeing to recognize negative thought spirals when they are happening! If I believe the reason why I can't connect with others is because I am inherently broken or deficient, I am shutting myself off from the very possibility of what all humans need; real, honest connection, and being seen for who we are. And, maybe not just being seen, but being APPRECIATED for who we are.

During dark times, I know it feels like being truly wanted or valued sounds impossible. Sometimes the idea of being loved as you are sounds ludicrous. But the truth is, you're not ACTUALLY broken, unlovable, unlikeable, or even truly alone. Every single person out there is their own kind of

messy weirdo doing their best with what they've got. And yes, sometimes that means you may not connect with those around you, but that doesn't mean "your people" aren't out there.

Love,
Thirty-Year-Old You

It's okay if you haven't found your people yet. Some find them as children, for others it takes decades.

The important thing is they are out there right now waiting for you.

If You Are Struggling with Feelings of Not Fitting in Anywhere, These Kind Drawings Are for You ♥

It isn't all downhill from here.
There are lots of good friends
you haven't met yet.

you have a lot of good to contribute, even if you are strange and shy

Hey. You can be a weirdo.
You can mess up, a lot.

You'll still be lovable
anyway.

YOU ARE ENOUGH today, tomorrow, always.

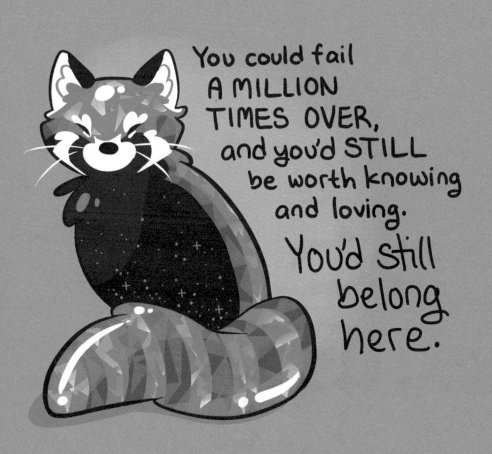

today is a
better day
because
you are
in it

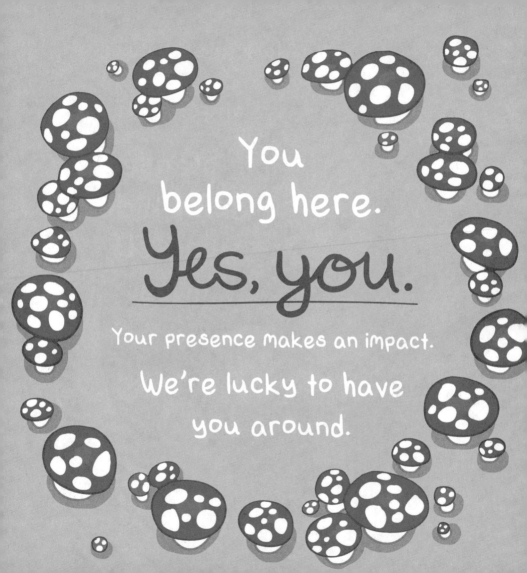

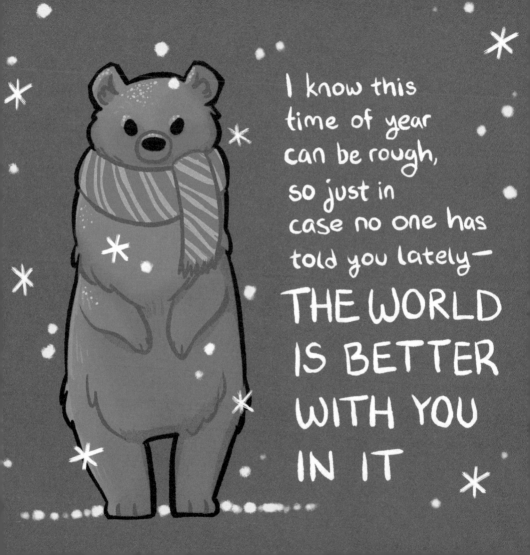

Here Are Some More Gentle
Reminders for You

It's not always that life is bad; sometimes you feel down because you haven't slept well, or eaten enough, or connected with someone in a while.

It's okay to be afraid of your thoughts, but all they really indicate is that your brain is misbehaving.

SELF-CARE WILL SEE YOU THROUGH.

I know you feel alone,

but there are lots of people who care about you and wish you well.

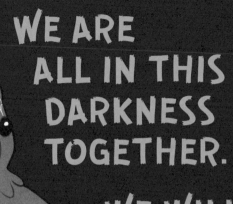

WE ARE
ALL IN THIS
DARKNESS
TOGETHER.

WE WILL
FIND A WAY
THROUGH.

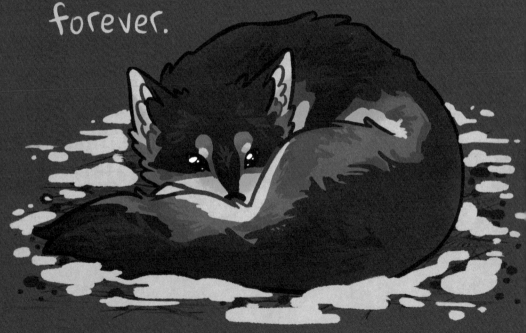
This feeling will pass. You're not stuck here forever.

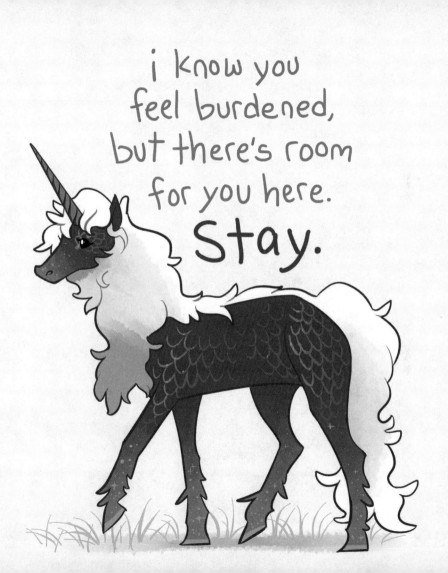

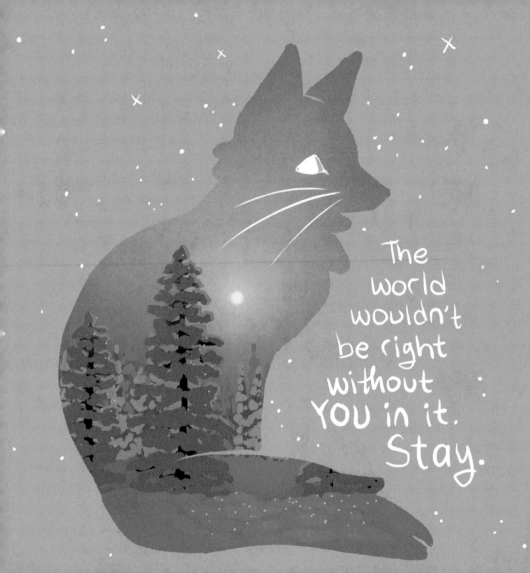

The
world
wouldn't
be right
without
YOU in it.
Stay.

Conclusion

Thank you so much for reading and spending this time with me! I hope you found some comfort and feelings of validation in this book. Please feel welcome to return to it again if you need a pep talk from a friend or a reminder that you're not alone in your struggles.

No matter what problem feels insurmountable right now, just remember: You're Strong, Smart, and YOU GOT THIS.

Love,
Kate

About the Author

Kate Allan is an author, artist, and the creator of the mental health art blog, *The Latest Kate*. She draws and writes with gentle comfort and encouragement about the trials and tribulations of life. A Southern California transplant, she enjoys anything bright, fluffy, or colorful, as can be seen in her work. When she isn't endeavoring to soak up every ray of sunshine, she works as a freelance designer and illustrator.

Twitter: @tlkateart
Instagram: @thelatestkate
Blog: thelatestkate.tumblr.com
FB: facebook.com/thelatestkate

Mango Publishing, established in 2014, publishes an eclectic list of books by diverse authors—both new and established voices—on topics ranging from business, personal growth, women's empowerment, LGBTQ studies, health, and spirituality to history, popular culture, time management, decluttering, lifestyle, mental wellness, aging, and sustainable living. We were recently named 2019 *and* 2020's #1 fastest growing independent publisher by *Publishers Weekly.* Our success is driven by our main goal, which is to publish high quality books that will entertain readers as well as make a positive difference in their lives.

Our readers are our most important resource; we value your input, suggestions, and ideas. We'd love to hear from you—after all, we are publishing books for you!

Please stay in touch with us and follow us at:

Facebook: Mango Publishing
Twitter: @MangoPublishing
Instagram: @MangoPublishing
LinkedIn: Mango Publishing
Pinterest: Mango Publishing

Sign up for our newsletter at www.mangopublishinggroup.com and receive a free book!

Join us on Mango's journey to reinvent publishing, one book at a time.